# Ketubbot

## Marriage Contracts from The Jewish Museum

Claudia J. Nahson

The Jewish Museum     New York
Under the auspices of The Jewish Theological Seminary of America

*Pomegranate*

San Francisco

Published by Pomegranate
Box 6099, Rohnert Park, CA 94927

Pomegranate Europe Ltd.
Fullbridge House, Fullbridge
Maldon, Essex CM9 4LE, England

Pomegranate Catalog No. A922
ISBN 0-7649-0618-6

Photography credits:
© The Jewish Museum, New York, NY

John Parnell: cover image; plates 1, 2, 3, 4, 5, 6, 7, 8,
    9, 10, 11, 12, 14, 15, 16, 17, 19, 20, 21, 22, 23, 24,
    26, 27, 29, 30, 31, 32, 33, 34, 35, 36, 38, 39, 40
Malcolm Varon: plate 13
Joseph Sachs: plate 18
Coxe-Goldberg: plate 25

**Library of Congress Cataloging-in-Publication Data**

The Jewish Museum (New York, N.Y.)
    Ketubbot: marriage contracts from the Jewish
Museum / introduction by Claudia J. Nahson. — 1st ed.
        p.  cm.
    Includes bibliographical references.
    - ISBN 0-7649-0618-6
    1. Ketubbah—Catalogs. 2. The Jewish Museum (New
York, N.Y.)—Catalogs. I. Nahson, Claudia J. II. Title.
NK1672.J53    1998
745.6'74924'0747471—dc21                97-43327
                                            CIP

Cover and interior design by
    Monroe Street Studios, Santa Rosa, California

*Front Cover image:* Ketubbah; Pisa, 1721, Plate 8.
*Back Cover Image:* Ketubbah; Isfahan, Persia, 1818,
    Plate 16.

Printed in Hong Kong
    07  06  05  04  03  02  01  00  99  98
    10  9   8   7   6   5   4   3   2   1

FIRST EDITION

# CONTENTS

# FOREWORD

Jewish law is distinguished for its long history of assuring women's rights in marriage by requiring the groom to present his bride with a written contract. The text of the contract, or *ketubbah,* details the husband's responsibility to provide his wife with food, clothing, and sexual satisfaction. The rabbis formulated clauses of the contract during the Talmudic period (250–400 C.E.), incorporating provisions composed as early as the first century B.C.E.

Some marriage contracts (plural *ketubbot)* also include articles of engagement, written either below or beside the main Aramaic text. When the texts appear side by side, they are organized on the page in a manner similar to parallel columns of texts in medieval manuscripts. Not only their composition but also the decorative motifs used to embellish *ketubbot* from the tenth through the eighteenth centuries echo the illumination of medieval Hebrew manuscripts.

Prior to the late nineteenth century, only contracts created for Sephardim and Jews resident in Islamic countries were decorated.[1] The Jewish Museum's collection of marriage contracts, although not large, is particularly strong in examples from Italy and Persia, and includes the earliest known contracts from Venice (1614) and Isfahan (1647). The Italian contracts were ornamented with both decorative motifs and human figures, some allegorical and others portraying genre scenes.

In this century, the Albert A. List family was among the first patrons to commission a *ketubbah* from a prominent artist. In 1961, Ben

---

1. The single exception is discussed in the Introduction.

Shahn created for the Lists a contract whose text served both as content and as decoration (Plate 38). Instead of surrounding the text with a decorative frame as had been done in the past, Shahn integrated a flowering vine, symbolic of the wife, with the lines of letters. The letters themselves incorporate decorative and symbolic forms. This work presaged an innovative contemporary development, the commissioning of decorated contracts by Ashkenazim.

This catalogue was suggested by Robin Cramer, Director of Product Development and Marketing in The Jewish Museum's shop, who has been developing a programme of reproductions and publications from the collection. Assistant Curator Claudia Nahson undertook the selection of works, their conservation and research, and wrote the accompanying texts

with her customary enthusiasm and thoroughness. Her understanding of the material is amply demonstrated in the Introduction to this book. Dr. Sarah E. Lawrence, Andrew W. Mellon Fellow in Judaica, assisted with editing the manuscript and with various other aspects of the project. Sheila Friedling, Editor of The Jewish Museum, gave of her expertise in reviewing the text. We thank all of them for their efforts.

*—Vivian B. Mann*
*Morris and Eva Feld Chair of Judaica*
*The Jewish Museum*

# ACKNOWLEDGMENTS

Thanks are due to Dr. Vivian B. Mann, Morris and Eva Feld Chair of the Judaica Department, who reviewed the manuscript numerous times and generously gave of her time and knowledge to answer my constant queries. I greatly benefited from the research done by current and former members of the Judaica Department, especially the work of Dr. Susan L. Braunstein, Curator of Archaeology and Judaica. The research of Dr. Shalom Sabar and Sharon Makover Assaf on Italian *ketubbot* in the collection was very helpful. The contents of the Introduction to this volume benefited from discussions with Dr. Abraham M. Mann. I am also indebted to Dr. Layla Diba and Prof. Maan Madina for their help with the reading of the Persian marriage contract from Khorasan Province (Plate 31). Thanks to Xiao Cui for translating the Chinese marriage certificate (Plate 36). Robin Cramer, Director of Product Development and Marketing, originated the idea of creating a book on The Jewish Museum's collection of *ketubbot* and managed the project with great patience and grace. I am grateful to Sheila Friedling, who edited the manuscript with great skill at very short notice, and to Irene Z. Schenck for her editorial comments. Thanks to Katie Burke at Pomegranate, who oversaw the publication, and to Annette Gooch, who edited the book for the publisher. Special thanks are due to Barbara Treitel, Manager of the Visual Resources Archive at the Museum, and to all other members of the Judaica Department for their help and support: Sharon Wolfe, Deena Barth-Fiedler, Denny Stone, and Hanah Fisher. Last but not least, I would like to thank Dr. Sarah E. Lawrence, Andrew W. Mellon Fellow in Judaica, for her valuable assistance with the editing of the manuscript and the photography of the works.

—*Claudia J. Nahson*

# INTRODUCTION

"It is forbidden for a husband to live with his wife without a *ketubbah,* even for an hour."

—*Babylonian Talmud, Baba Kama 89a*

At the end of every circumcision ceremony, those assembled pronounce, "As he has been initiated into the covenant [of Abraham], so may he be introduced to [the study of] Torah, to marriage, and to the performance of good deeds." This verse from the Babylonian Talmud (Shabbat 137b) encompasses the main goals of a traditional Jewish life: study of Torah and fulfillment of the commandments, marriage, creation of a family to ensure Jewish continuity, and performance of good deeds.

Marriage is one of the most important *mitzvot,* or commandments, in Judaism, and the Scriptures are replete with verses encouraging the union of man and woman. Early in the Book of Genesis we read, "It is not good that the man should be alone..." (Gen. 2: 18). Rabbinic literature emphasizes that "He who has no wife is not a proper man... [he lives] without joy, blessing, goodness..." (Babylonian Talmud, Yevamot 62b). Marriage is considered to be so important that a man is even allowed to sell a Torah scroll in order to marry (Babylonian Talmud, Megillah 27a).

One of the essential elements of a Jewish wedding ceremony is the writing and transfer of a marriage contract, or *ketubbah* (plural *ketubbot*). The ketubbah was originally formulated to protect a woman's rights in marriage, and later was extended to safeguard the financial obligations of the groom toward his bride in cases of divorce or death. According to Jewish law, it is the husband who divorces the wife; therefore the ketubbah was designed "so that he should

not deem it an easy thing to send her away" (Babylonian Talmud, Ketubbot 11a). Since the contract was to be a practical document understood by all parties, it was written in Aramaic, the lingua franca of the ancient world. Only the date was written in Hebrew. Although Aramaic has fallen into disuse, it continues to be the language of traditional ketubbot to this day.

The Jewish Museum collection includes more than seventy ketubbot from various countries; forty decorated examples are presented in this publication. Most of the ketubbot date from the early seventeenth century to the present. The majority come from Italy, Persia (Iran), and the United States, but a few originated in the Ottoman Empire (Turkey, Greece, and the Balkans) and in the Sephardi community of Hamburg. Although most ketubbot are based on a traditional text, the terms of engagement and the decoration of the contract offer a glimpse into the lives of different communities as well as the socioeconomic status of particular families. Some examples bear lavish decorations that reflect a high degree of acculturation to the societies in which Jews lived.

The earliest surviving ketubbah dates to the fifth century B.C.E. and was excavated in the Jewish colony of Elephantine, Egypt. Early ketubbot were written in accord with either Palestinian or Babylonian textual traditions. While no set formula was used for Palestinian ketubbot, Babylonian examples follow a standard text that is the basis for the one used today.

The traditional text begins with the date of the wedding according to the Hebrew calendar. The city in which the wedding was performed and its geographical location are then indicated, without specifying the country, since borders

shifted frequently. In American ketubbot, however, the country is often added. The first names of the groom and the bride are written as well as those of their fathers, and the status of the bride—virgin, divorcée, or widow—is noted. The stipulations of the marriage are then listed, including the obligations of a husband toward his wife and the amount to be paid by the husband or his heirs in case of divorce or death: 200 *zuzim* (silver coins) for a virgin and 100 *zuzim* for a divorcée or a widow. An equivalent of these amounts in the local currency is usually fixed. The Sephardi ketubbah documents the dowry brought by the wife to the marriage, which may include silk scarves, jewelry, and other valuables. The husband could voluntarily add to both the dowry and the amount he was obligated to pay to his wife if the marriage were dissolved.

The custom of decorating the ketubbah was first practiced in the Middle East, most likely as a result of the public nature of the wedding ceremony, which included the reading aloud of the contract and the display of the dowry. These customs were also observed in pre-expulsion Spain and were later practiced in Italy by Sephardi exiles. In the Sephardi tradition, the contract reading had social importance, and therefore the appearance of the ketubbah was relevant. In the Ashkenazi tradition, the ketubbah was a standard text read to fulfill a legal obligation, and no importance was given to the appearance of the document.[1] However, a unique decorated ketubbah from Krems, Austria, dated 1391–92 has survived.

The earliest extant decorated ketubbot date to the tenth to thirteenth centuries and were found in the *genizah* of the Ben Ezra Synagogue in Cairo; a *genizah* is a repository of worn

Hebrew texts that are "hidden" to prevent their profanation. A few decorated examples exist from medieval Spain, but all of these early ketubbot bear simple ornamentation, consisting mostly of colorful floral elements or birds, and micrography—a traditional Jewish form that uses words to shape ornamental patterns or human and animal forms. That no lavishly decorated ketubbot have survived from the medieval period does not mean, however, that they did not once exist.

The decoration of a ketubbah was not only an embellishment but was included also for practical reasons. A major concern of Spanish rabbis was that no changes be made to the provisions of the ketubbot after they were signed. To prevent tampering with the text, Rabbi Simon ben Ẓemaḥ Duran of Majorca (1361–1444) suggested that the empty spaces of a ketubbah be filled with decoration.[2]

With the expulsion of the Jews from Spain and Portugal at the end of the fifteenth century, the tradition of decorating ketubbot was taken to Italy, Holland, England, North Africa, and the Ottoman Empire. The practice flourished in Italy, probably because the public reading of the ketubbah during the marriage ceremony became popular in the sixteenth century and because Italians had a tradition of decorated documents. During the eighteenth century, the decoration of ketubbot became so extravagant that rabbis were forced to enact laws limiting the amount of money that could be spent on the decoration of a marriage contract.

All of the fourteen Italian ketubbot featured in this book are written on parchment and are lavishly decorated. Italian contracts stem predominantly from northern Italy, with a

few examples from central Italy, since Jews had been expelled from other regions before the form became popular. Ketubbot were commissioned by Sephardi, Ashkenazi, and native Italian Jews alike.[3] The Jewish Museum owns one of the earliest decorated ketubbot extant from Italy; it was written in Venice and dated 1614 (JM 68-60, Plate 1). Its composition of paired horseshoe arches reflects the Spanish origin of the families.

Italian marriage contracts often include both the main text—the contract of marriage—and the articles of engagement, or *tena'im*. This practice is also observed in other Mediterranean countries, such as Greece and Yugoslavia. As for the decoration of Italian ketubbot, the inclusion of the coats of arms of the two families is a common feature, an imitation of the practices of the local nobility. Other popular decorative images

are the signs of the zodiac, personifications of the four seasons, and allegories representing the virtues of marriage (Righteousness, Hope, and Fame, among others). Depictions of biblical scenes featuring heroes whose names were borne by either the groom, bride, or their fathers are also common. Often a decorative frame was purchased beforehand and the text inscribed later.

The decoration of Italian ketubbot was inspired by both Jewish and Christian art. For instance, the use of an archway to frame the text can be traced to the title pages of Hebrew printed books—northern Italy was a main center of Hebrew printing—but may also be linked to local architecture or sculpture.[4] The decoration of a ketubbah from Livorno in the collection of The Jewish Museum (U 8440, Plate 10) was inspired by the work of the sculptor

Giovanni di Isidoro Baratta of Carrara (1670–1747), who worked both for the local church and synagogue. Motifs such as the signs of the zodiac and biblical scenes were common on majolica plates displayed at Christian weddings as symbols of wealth, in the same fashion that decorated ketubbot were displayed at Jewish weddings.[5]

A group of Italian ketubbot in the collection was decorated with cut-out designs, a technique popular in the second half of the eighteenth century in the cities along the northern Adriatic coast.[6] This type of frame featuring biblical scenes, the signs of the zodiac, and floral and animal decoration seems to have originated in the port of Ancona.[7] A ketubbah in the Museum's collection from that city dated 1793 (U 9936, Plate 15) includes empty shields for the coats of arms; a second example from Trieste

dated 1774 (F 5355, Plate 11) features biblical scenes that bear no relationship to the text, indicating that the decorative frames were created prior to the sale of the ketubbot.

A few Sephardi ketubbot from countries other than Italy are part of The Jewish Museum collection, three of which are featured in this publication: a beautifully decorated ketubbah from Hamburg, dated 1678 (S 449, Plate 4), commissioned for the wedding of Sarah, daughter of Isaac Senior (Manuel) Teixeira and Moses Nunes Henriques; an 1830 ketubbah (S 142, Plate 18) from Rhodes identified with the prominent Soriano family; and a ketubbah from Constantinople (Ottoman Turkey), dated 1866 (JM 200-68, Plate 24), written for the parents of Edouard Roditi.

Ketubbot produced in the Near East are very different from European examples: usually

written on paper, they are strongly influenced by Islamic art in their lack of figures and their decoration with aniconic motifs. Persia was the most important center of ketubbah illumination in the Islamic world. In fact, Muslim law requires a contract in order to legalize a marriage, and in Persia it was customary for Muslims to decorate marriage contracts.[8] Since Jewish law also requires a contract, Persian Jews seem to have modeled their marriage contracts on those of the Muslims.

Different ornamental traditions developed in the various cities where Persian Jews lived: Isfahan, Teheran, Yezd, and Hamadan, among others. Examples of marriage contracts from all of these cities are in the collection of The Jewish Museum. Although most were produced in the nineteenth and twentieth centuries, when decorated ketubbot were popular, an example from Isfahan, dated 1647 (F 3901, Plate 2), with stamped patterns, is the earliest Persian contract in existence. Other Isfahani ketubbot in the collection feature the motif of a lion in front of the rising sun, a popular symbol of Persia that reflects the Jewish community's national pride.

One Persian marriage contract in The Jewish Museum collection (F 5724, Plate 31) is a moving testimony to Jewish history. Written in the Persian language, the contract probably originated in the holy Shi'ite center of Meshed in northeast Iran. Jews first arrived in the city in 1740 under the protection of Nadir Shah, but after his assassination in 1747, they became subject to frequent persecution. In 1839 all the Jews of Meshed were forced to convert to Islam, and each convert became known as *Jadid al-Islam*, or "New Muslim." Jews, however, continued to observe their religion in

secret, which led to the celebration of two wedding ceremonies: a public Muslim ceremony for which a contract in Persian was prepared (see F 5724, Plate 31) and a private ceremony that involved transfer of the traditional Jewish ketubbah. Bride and groom were betrothed from childhood to avoid intermarriage, since the authorities encouraged converts to wed Muslim subjects.[9]

Although originally the custom of decorating the ketubbah prevailed only in Oriental and Sephardi communities, the tradition became popular in the United States during the twentieth century. The Jewish Museum collection includes several American ketubbot. Many of the examples are simple printed forms, either in both English and Aramaic or only in English. Others, however, are hand-painted with lively decorations. A ketubbah from New York, dated 1899 (F 5668, Plate 33), features a printed text decorated with an urn of flowers, a popular motif in American folk art.

In recent years, contemporary artists have become interested in the decorated ketubbah as an art form. American artists such as Ben Shahn (b. Lithuania, 1898–1969) and Chaim Gross (b. Galicia, 1904–1991) have integrated decoration and text, blurring the boundaries between the two (see ketubbot JM 99-72 and JM 6-77, Plates 38 and 9). Gregg Handorff (b. 1959), on the other hand, has eliminated the decorative frame, focusing on the text as the subject of his art (see 1990-146, Plate 40). More and more artists continue to create this art form in response to the demands of young couples.

# NOTES

1. S. Sabar, *Ketubbah: Jewish Marriage Contracts of the Hebrew Union College Skirball Museum and Klau Library* (Philadelphia and New York: The Jewish Publication Society, 1990), 7–9.

2. I. Epstein, *The Responsa of Rabbi Simon b. Zemaḥ Duran* (London: 1930), 83–84.

3. Native Italian Jews were those living in Italy since the Roman period.

4. Sabar, *Ketubbah,* 16; S. Sabar, *Mazal Tov: Illuminated Jewish Marriage Contracts from the Israel Museum Collection* (Jerusalem: Israel Museum, 1993), 19–25.

5. J. Gutmann, *The Jewish Life Cycle* (Leiden: E.J. Brill, 1987), 13; Sabar, *Ketubbah,* 21.

6. N. L. Kleeblatt and V. B. Mann, *Treasures of The Jewish Museum* (New York: Universe Books and The Jewish Museum, 1986), 118.

7. Sabar, *Ketubbah,* 47.

8. Sabar, *Ketubbah,* 24. For examples of Muslim wedding contracts, see *Iranian Wedding Contracts of the Nineteenth and Twentieth Centuries,* ed. L. S. Diba, exhibition catalogue (Teheran: Negarestan Museum, 1976).

9. S. Sabar, "A Decorated Marriage Contract of the Crypto–Jews of Meshed from 1877," *Kresge Art Museum Bulletin* 5 (1990): 24.

# Ketubbot

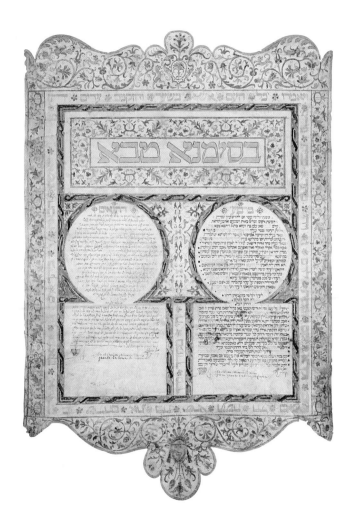

Plate 1

*Bride: Gracia, daughter of Aaron de Paz*
*Groom: Abraham Abravanel, son of*
*    Solomon Abravanel*
*Venice, 1614*
*Paint and ink on parchment*
*35 5/8 x 24 3/4 in.; 90.5 x 62.9 cm*
*Gift of Jakob Michael, JM 68-60*

---

*This is one of the earliest extant decorated*
*ketubbot from Italy and the earliest in the*
*collection of The Jewish Museum. The bride*
*and groom belonged to very prominent*
*Sephardi families. As customary in Italian*
*marriage contracts, this ketubbah includes*
*the main text; the contract of marriage, at*
*right; and the articles of engagement, or*
*tena'im, at left. Their framing through*
*paired horseshoe arches suggests Spanish influ-*
*ence. The biblical inscriptions decorating the*
*ketubbah mention the house of Perez, ances-*
*tors of King David, as the Abravanel family*
*claimed Davidic descent.*

Plate 2

*Bride: Esther, daughter of Mashiaḥ son of*
*    Kadadad*

*Groom: Mordecai, son of Judah son of Naṣr*

*Isfahan, Persia, 1647*

*Ink, watercolor, gold and silver paint, and*
*    block print on parchment*

*32 x 24 in.; 81.3 x 61 cm*

*Gift of Dr. Harry G. Friedman, F 3901*

---

*This is the earliest extant decorated ketubbah*
*from Persia. Like the rest of Persian Jewry,*
*Isfahan Jews experienced severe persecutions in*
*the seventeenth century and were forced to con-*
*vert to Islam under the rule of Shah Abbas II*
*(1642–1666), which may explain the scarcity*
*of ketubbot from this period. But, as this mar-*
*riage contract indicates, Jews still managed to*
*observe their religion in secret. Unlike later*
*painted examples, the decoration of this con-*
*tract was created by a repeat of stamped pat-*
*terns. Biblical verses form the inner and outer*
*frames of the ketubbah.*

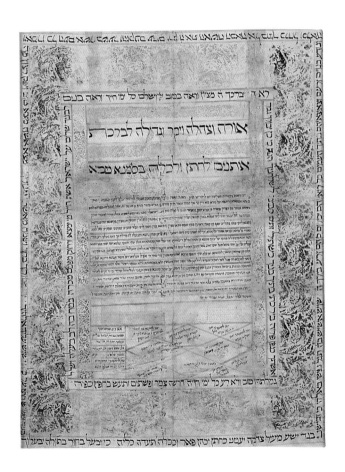

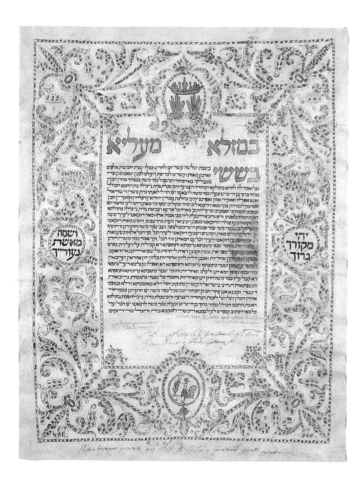

Plate 3

*Bride: Gimila, daughter of Barukh son of*
*    Moses Luzzatto*
*Groom: Moses, son of Aharon ha-Cohen*
*Monselice (Province of Padua), 1659*
*Ink on parchment*
*24 ¹³/16 x 20 ⁵/8 in.; 63 x 52.4 cm*
*Gift of Dr. Harry G. Friedman, F 3799*

*The coats of arms of the two families often*
*appear on Italian marriage contracts;*
*here they are depicted in shields above and*
*below the text. The groom's coat of arms is*
*a pair of blessing hands surmounted by*
*the crown of priesthood. A rooster perched*
*on a branch, with a crescent half-moon*
*and three stars above, is the bride's family*
*emblem. Her family name—Luzzato—*
*derives from Lausitz, Saxony, from which*
*the family emigrated to Italy in the mid-*
*fifteenth century.*

Plate 4

*Bride: Sarah, daughter of Isaac Senior (Manuel) Teixeira*

*Groom: Moses Nunes Henriques*

*Hamburg, 1678*

*Ink, gouache, and gold paint on parchment*

*26 x 23½ in.; 66 x 59.7 cm*

*Gift of Maurice Hermann, S 449*

*The floral frame surrounding the text in this contract is composed predominantly of tulips, reflecting the families' Dutch origins. A pierced heart and a crown with a heart above the text express the love of the new couple. As was customary in Sephardi ketubbot, the groom added his signature to those of the witnesses to the marriage.*

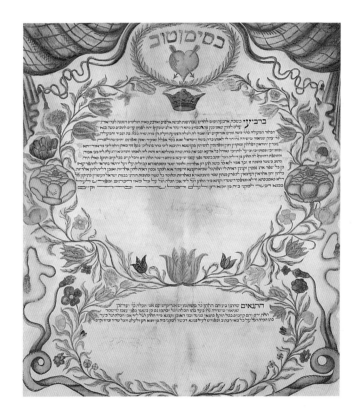

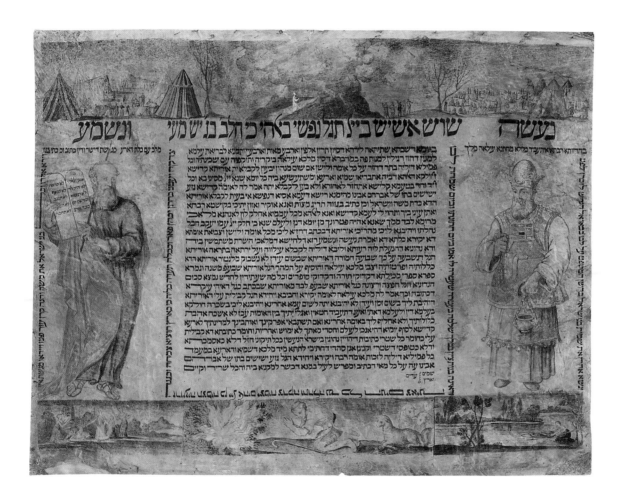

Plate 5

*Symbolic Marriage Contract for* Shavuot
*Italy, 17th–18th century*
*Ink and paint on parchment*
*21 7/8 x 29 in.; 55.6 x 73.7 cm*
*Gift of Dr. Harry G. Friedman, F 661*

*This rare ketubbah celebrates the symbolic union between God, the bridegroom, and the People of Israel, the bride, a conceit derived from a Jewish legend. This spiritual wedding takes place on the holiday of* Shavuot, *and the witnesses are the Heavens and the Earth. The story of Moses, including the Giving of the Law that is commemorated on* Shavuot, *is illustrated above and below the text, which is flanked by the figures of Moses and Aaron. The composition is similar to those on title pages of Hebrew and German printed books as well as those of Hebrew manuscripts.*

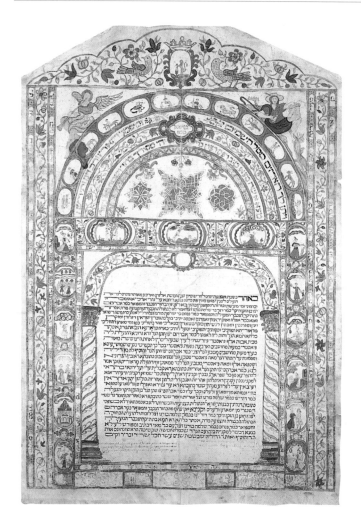

Plate 6

*Bride: Esther, daughter of Pinḥas son of*
*Solomon Borgho*

*Groom: Abraham, son of David son of*
*Solomon Borgho*

*Siena, 1700*

*Ink, gouache, and gold leaf on parchment*

*32 $^{11}$/16 x 22 $^{15}$/16 in.; 83 x 58.3 cm*

*Gift of Dr. Harry G. Friedman, F 2407*

*The bride and groom were first cousins.*
*The Borgho family coat of arms, a lion*
*holding a censer, is depicted on top in the*
*center. Various biblical and secular scenes*
*comprise the decoration. The large alle-*
*gorical figures on either side of the upper*
*arch represent Fame (an angel blowing a*
*trumpet) and Profit (a man with a bag*
*of seeds). The zodiac follows the Hebrew*
*calendar but includes a unicorn with a*
*virgin, Christian symbols that represent*
*the sign Virgo.*

Plate 7

*Bride: Luna Batyah, daughter of Joseph*
    *Ventura*

*Groom: Solomon, son of Abraham*
    *Mussafia*

*Venice, 1701*

*Ink and paint on parchment*

*24 x 18¼ in.; 61 x 46.3 cm*

*Gift of Dr. Harry G. Friedman, F 1265*

*This ketubbah is decorated with floral motifs and the signs of the zodiac. Although the bride's family—Ventura— had its own emblem (a rampant deer facing left), it is not featured on this ketubbah, probably because the bridegroom's family did not have an emblem. Instead, the shield reserved for the emblems has been filled with an inscription, indicating that the decorative frame was made first and the text added later, a common practice.*

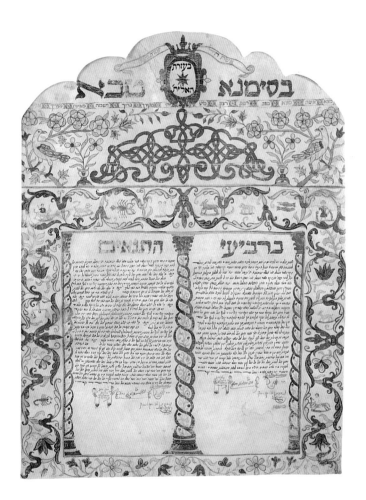

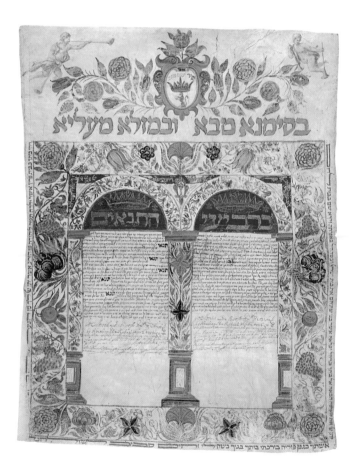

Plate 8

*Bride: Sarah, daughter of Samuel
    Henriques Miranda*
*Groom: Moses, son of Joseph De Leon*
*Pisa, 1721*
*Ink and paint on parchment*
*24¼ x 18¹⁵⁄₁₆ in.; 61.6 x 48.1 cm*
*Gift of Dr. Harry G. Friedman, F 3547*

The Grand Duke Ferdinand I of Tuscany
(r. 1587–1609) invited Jews to settle in
Pisa and Livorno in the late sixteenth cen-
tury; they included descendants of Spanish
conversos. *It is therefore not surprising
that, in this ketubbah from Pisa, both bride
and groom are of Spanish origin. The wit-
nesses have signed their names in Italian
instead of Hebrew. The groom's family
emblem, featured in the shield above,
includes a lion (*león *in Spanish). The rep-
resentation of seminude figures in the top
corners of the document indicates the influ-
ence of Italian art.*

26

Plate 9

*Bride: Leah, daughter of Menahem*
*D'Italia*

*Groom: Samuel, son of Meshullam*

*Verona, 1733*

*Ink and paint on parchment*

*29 ½ x 19 ½ in.; 75 x 49.5 cm*

*Gift of Isidore M. Cohen, JM 81-76*

*Above the text, within a shield topped by a*
*portrait of a man with feathery headdress,*
*are the coats of arms: at left, a squirrel*
*perched against a fruit tree, symbol of the*
*D'Italia family of printers to which the*
*bride belonged; at right, the zodiac sign of*
*Pisces within a Star of David for the*
*groom. The amount to be paid by the hus-*
*band or his heirs in case of divorce or*
*death was half the customary amount,*
*because the bride was a widow.*

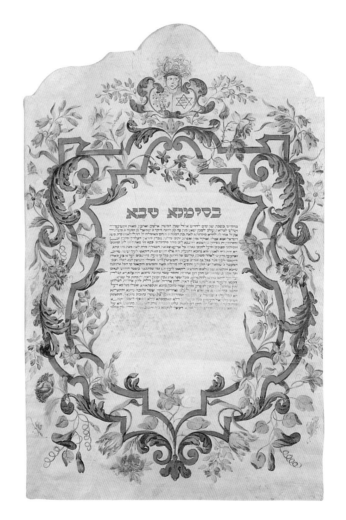

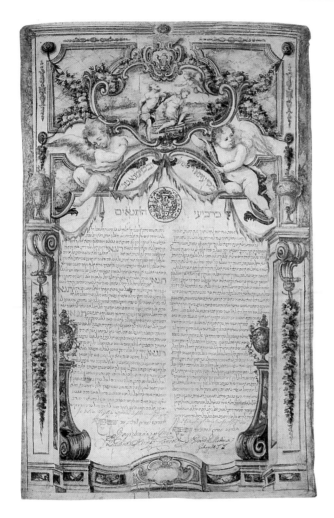

Plate 10

*Bride: Rachel, daughter of Isaac*
*    Yeshurun*

*Groom: Elijah, son of Solomon Judah*
*    Ḥayyim Teglio al-Fierino*

*Livorno, 1751*

*Ink, gouache, and gold paint on*
*    parchment*

*21 x 13 1/2 in.; 53.3 x 34.3 cm*

*Gift of an anonymous donor, U 8440*

*As her father had died, the bride's dowry*
*was given to the groom by her uncle. The*
*decoration of this ketubbah was inspired*
*by the work of Giovanni di Isidoro*
*Baratta of Carrara (1670–1747), who*
*designed the altar of the Livorno*
*Cathedral as well as the Torah ark of*
*that city's synagogue. The scene depicted*
*in a cartouche above the text—the*
*Binding of Isaac—refers to the name of*
*the father of the bride.*

Plate 11

*Bride: Grazia, daughter of Asher Fano*

*Groom: Samson, son of Kalonymos
    ha-Levi*

*Trieste, 1774*

*Ink, gouache, and gold paint on cut-out
    parchment*

*27¾ x 22¼ in.; 70.5 x 56.5 cm*

*Gift of Dr. Harry G. Friedman, F 5355*

*The text of this ketubbah was added after
the decorative frame was made, since it
overlaps the border in many places. For
the same reason the biblical scenes—the
Binding of Isaac and the Temptation of
Adam and Eve, above left and right, and
Lot and his two daughters, at bottom—
bear no relationship to the text. The scenes
were probably chosen to remind couples to
avoid a sinful life and instead lead a life
of faithfulness.*

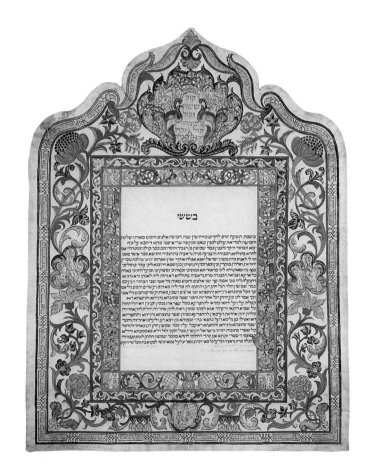

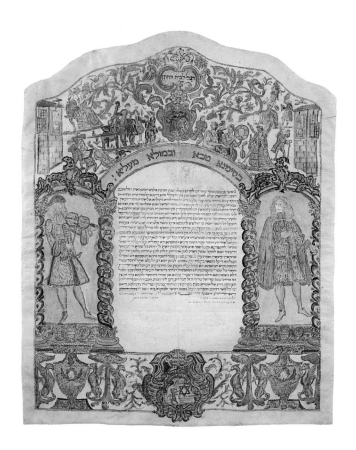

Plate 12

*Bride: Eleonora, daughter of Benjamin Segré*

*Groom: Mordecai, son of Azriel Treves*

*Vercelli, 1776*

*Ink and paint on parchment*

*24¼ x 20 in.; 61.6 x 50.8 cm*

*Gift of Samuel and Lucille Lemberg, JM 43-61*

*Although some Italian contracts depict the bride and groom, very few represent the wedding party or the attendant musicians, shown here in lavish costumes and hairdos.*

Plate 13

*Bride: Speranza Simḥah, daughter of Barukh
ha-Levi*

*Groom: Jacob Solomon Shabbetai, son of Joseph
Ḥayyim Zinguli*

*Ancona, 1781*

*Ink, paint, and gold leaf on parchment*

*34½ x 23¼; 87.6 x 59 cm*

*Gift of the Danzig Jewish Community, D 305*

---

*The text is surrounded by an elaborate border
comprising framed scenes, allegorical figures,
and decorative elements. The scenes—Jacob's
Dream of the Ladder, above, and Joseph as gov-
ernor of Egypt, below—are drawn from the lives
of two biblical heroes who are the namesakes of
the bridegroom and his father. Above, within a
shield, is the bride's coat of arms: a pitcher and
laver symbolic of the tribe of Levi, to which her
family belonged. The groom's emblem cannot be
deciphered. Flanking the text are the allegorical
figures for Righteousness (at right) and Hope
(at left), representing a virtuous marriage.*

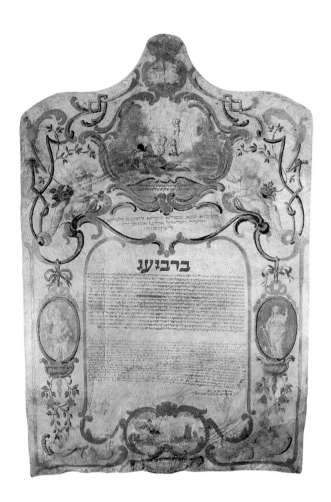

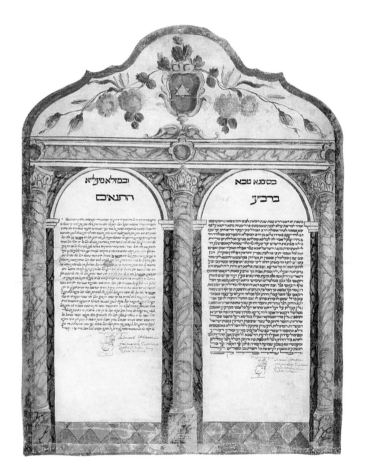

Plate 14

*Bride: Bella, daughter of Samuel Campos*
*Groom: Jacob Pardo, son of David Pardo*
*Ragusa, 1790*
*Ink and paint on parchment*
*28³/₁₆ x 22¹/₈ in.; 71.6 x 56.2 cm*
*Gift of Dr. Harry G. Friedman, F 1264*

*The bridegroom, Jacob Pardo, was the*
*rabbi of Ragusa, which explains the many*
*honorific terms used for him in the ketub-*
*bah. A maritime city-state on the Dalma-*
*tian coast, Ragusa became Dubrovnik,*
*Yugoslavia, in 1918. Although autono-*
*mous until 1808, the city was always*
*either a Turkish or Venetian protectorate,*
*which accounts for the similarities*
*between this ketubbah and examples from*
*northern Italy.*

Plate 15

*Bride: Simḥah, daughter of Ephraim Prato*

*Groom: Jacob Solomon, son of Shabbetai Ḥayyim Matirini*

*Ancona, 1793*

*Ink and paint on cut-out parchment*

*27 x 18¾ in.; 68.6 x 47.6 cm*

*Gift of an anonymous donor, U 9936*

───※───

*The empty shield above the text indicates that the decorative frame was prepared prior to the ketubbah's sale. The families had no coats of arms.*

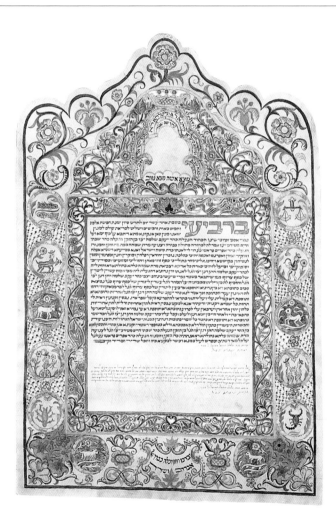

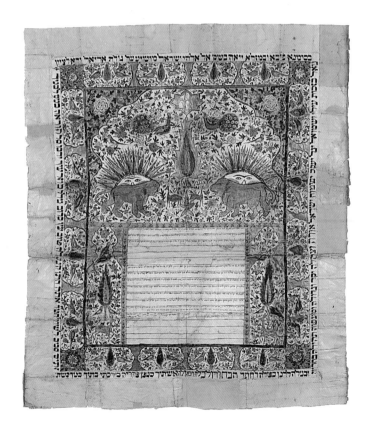

Plate 16

*Bride: Rebecca, daughter of David*
*Groom: Abba, son of Asher*
*Isfahan, Persia, 1818*
*Ink, watercolor, and gold paint on paper*
*39 x 34 in.; 99.1 x 86.4 cm*
*Gift of Dr. Harry G. Friedman, F 5231*

*The use of the motif of the lion in front of*
*the rising sun, a popular symbol of Persia,*
*reflects the national pride of the Jews of*
*Isfahan, who believed they were the oldest*
*Jewish community in the country.*

Plate 17

*Bride: Arzo, daughter of Jacob*
*Groom: Samuel, son of Aaron*
*Hamadan, Persia, 1821*
*Ink and paint on paper*
*17¼ x 14¼ in.; 43.8 x 36.2 cm*
*Gift of Dr. Harry G. Friedman, F 5819*

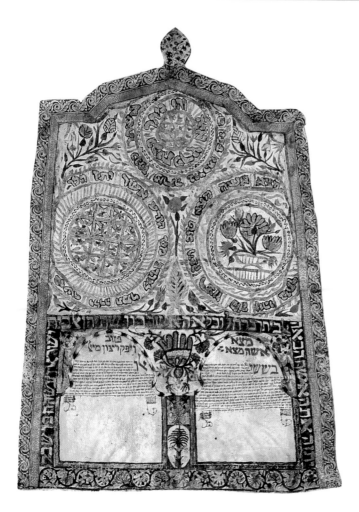

Plate 18

*Bride: Rebecca, daughter of Moses
    Soriano*

*Groom: Joseph, son of Moses Tarica*

*Rhodes, Ottoman Empire, 1830*

*Ink and paint on parchment*

*30¾ x 22¼ in.; 78.1 x 56.5 cm*

*The H. Ephraim and Mordecai Benguiat
    Family Collection, S 142*

---

*At left are the terms of engagement*
(tena'im) *and, at right, the marriage
contract* (ketubbah), *an arrangement
also found on Italian ketubbot. The
Soriano family, to which the bride
belonged, was very prominent on Rhodes.
The Jewish Museum owns a Torah crown
and a matching Torah shield donated by
this family to the* Kahal Gadol *Synagogue
of Rhodes.*

Plate 19

*Bride: Malkah, daughter of Natan*
  *Orvieto*
*Groom: Joseph, son of Solomon Pasigli*
*Florence, 1836*
*Paint, ink, and gold leaf on parchment*
*25 1/2 x 19 5/16 in.; 64.8 x 49 cm*
*Gift of Dr. Harry G. Friedman, F 3548*

*While Florentine ketubbot of the seven-
teenth and eighteenth centuries have very
simple ornamentation or none at all,
some nineteenth-century ketubbot such as
this one are presented within a massive
architectural frame. A shield above is
inscribed "GR," initials of the first names
of bride and groom, Giuseppe and
Regina (Yosef and Malkah in Hebrew).*

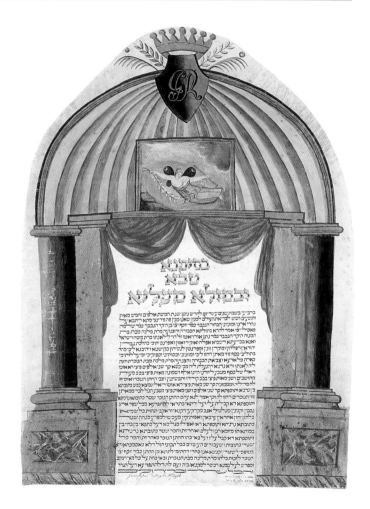

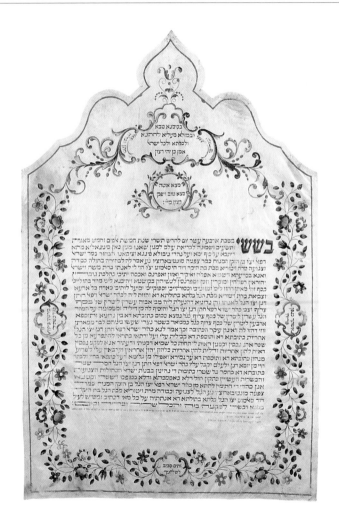

Plate 20

*Bride: Vittoria, daughter of David Ḥai
Salmoni*

*Groom: Israel Raphael, son of Ẓefaniah
Montibarozzio*

*Senigallia, 1837*

*Ink and paint on parchment*

*24⅝ x 16⅝ in.; 62.5 x 42.2 cm*

*The Rose and Benjamin Mintz
Collection, M 199*

Plate 21

*Bride: Zilpah, daughter of Yair*

*Groom: Simantov, son of Benjamin*

*Sena (Sanandaj), Persian Kurdistan,*
*   1848*

*Ink, gouache, and pencil on paper*

*17 3/8 x 13 5/8 in.; 44.1 x 34.6 cm*

*Gift of Ruth O. Gildesgame, 1994-68*

*The decoration of this ketubbah combines*
*the motif of the lion in front of the rising*
*sun, a national symbol of Persia typically*
*used in ketubbot from Isfahan, with a*
*frame comprising a series of quatrefoils*
*alternating with pitchers, popular in*
*ketubbot from Sena, where this example*
*was produced. The appearance of these*
*two decorative devices on the same ketub-*
*bah could indicate that the document*
*commemorates the wedding of a local*
*Sena Jew to a member of a family with*
*ties to Isfahan.*

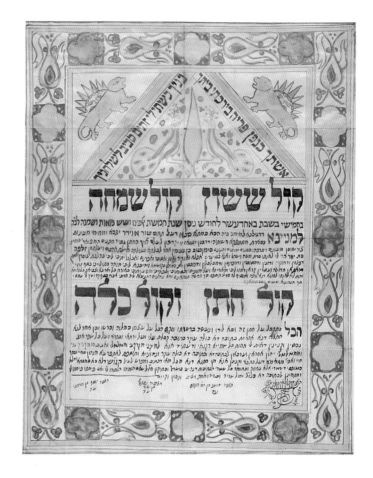

Plate 22

*Bride: Caroline Elsasser (Leah, daughter of Asher)*
*Groom: Cornelius Roos (Moses, son of Raphael)*
*New York, 1852*
*Printer: J. Bien, New York*
*Ink and print on paper; cardboard case*
*13½ x 14½ in.; 34.3 x 36.8 cm*
*Gift of James H. Abraham, JM 71-59*

*The contract is bilingual and includes a certificate in English at left and the original Aramaic text at right. The wedding took place at Congregation Emanu-El of the City of New York. Rabbi Leo Merzbacher, one of the founders of the synagogue in 1845, officiated.*

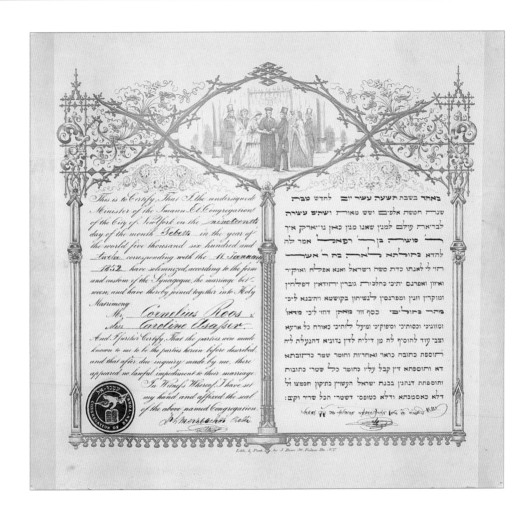

This is to Certify, That I, the undersigned Minister of the Imanu El Congregation of the City of New York on the *nineteenth* day of the month *Tebeth* in the year of the world five thousand six hundred and *Twelve* corresponding with the *11 January* *1852* have solemnized, according to the form and custom of the Synagogue, the marriage between, and have thereby joined together into Holy Matrimony

Mr. *Cornelius Roos* &
Miss *Caroline Asasser*

And I further Certify, That the parties were made known to me to be the parties herein before described, and that after due inquiry made by me, there appeared no lawful impediment to their marriage. In Witness Whereof, I have set my hand and affixed the seal of the above named Congregation.

*S. Merzbacher Rabbi*

בְּאֶחָד בְּשַׁבָּת תְּשָׁעָה עֶשֶׂר יוֹם לְחֹדֶשׁ טֵבֵת שְׁנַת חֲמֵשֶׁת אֲלָפִים וְשֵׁשׁ מֵאוֹת וּשְׁתֵּים עֶשְׂרֵה לִבְרִיאַת עוֹלָם לְמִנְיַן שֶׁאָנוּ מְנִין כָּאן נוּ־יָארְק אֵיךְ

רַבִּי מוֹשֶׁה בֶּן רַבִּי רְפָאֵל אָמַר לָהּ לְהָדָא בְּתוּלְתָּא קַרוֹלִינֶע בַּת רַבִּי אַשֶׁר

הֲוִי לִי לְאִנְתּוּ כְּדַת מֹשֶׁה וְיִשְׂרָאֵל וַאֲנָא אֶפְלַח וְאוֹקִיר וְאֵיזוֹן וַאֲפַרְנֵס יָתִיכִי כְהִלְכוֹת גּוּבְרִין יְהוּדָאִין דְפָלְחִין וּמוֹקְרִין וְזָנִין וּמְפַרְנְסִין לִנְשֵׁיהוֹן בְּקוּשְׁטָא וִיהִיבְנָא לִיכִי מֹהַר בְּתוּלַיְכִי כֶּסֶף זוּזֵי מָאתָן דַחֲזֵי לִיכִי מִדְאוֹרַיְתָא וּמְזוֹנַיְכִי וּכְסוּתַיְכִי וְסִפּוּקַיְכִי וּמֵיעַל לְוָתַיְכִי כְּאוֹרַח כָּל אַרְעָא וּצְבִי עוֹד לְהוֹסִיף לָהּ מִן דִילֵיהּ לַדֵין נְדוּנְיָא דַהֲנְעֵלַת לֵיהּ הַרֵי זֹאת הַתּוֹסֶפֶת כְּתוּבָּה קְרָאוּ וְאַחֲרָיוּת וְחוֹמֶר שְׁטַר כְּתוּבְּתָא דָא וְהַתּוֹסֶפְתָּא דֵין קַבֵּל עָלָיו כְּחוֹמֶר כָּל שְׁטָרֵי כְתוּבּוֹת וְתוֹסֶפְתָּא דְנָהֲגִין בִּבְנַת יִשְׂרָאֵל הָעֲשׂוּיִין כְּתִיקוּן חֲכָמֵינוּ זִ"ל דְּלָא כְּאַסְמַכְתָּא וּדְלָא כְטוֹפְסֵי דִשְׁטָרֵי הַכֹּל שְׁרִיר וְקַיָם:

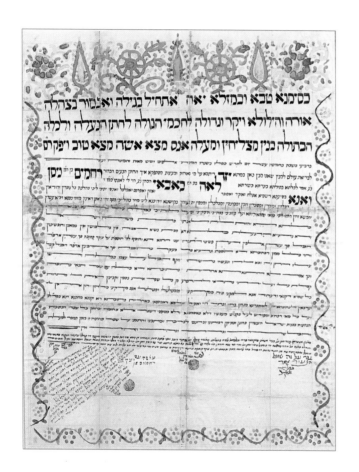

Plate 23

*Bride: Leah, daughter of Babai*
*Groom: Raḥamim, son of Nissan*
*Yezd, Persia, 1864*
*Ink and watercolor on paper*
*22 x 17¹/₄ in.; 55.9 x 43.8 cm*
*Max Korshak Collection, JM 65-76*

Plate 24

*Bride: Luna, daughter of Naftali Galipoliti*
*Groom: David Roditi, son of Nissim Israel Roditi*
*Constantinople, Ottoman Turkey, 1866*
*Ink, pencil, and crayon on paper*
*38 3/16 x 21 15/16 in.; 97 x 55.7 cm*
*Gift of Edouard Roditi, JM 200-68*

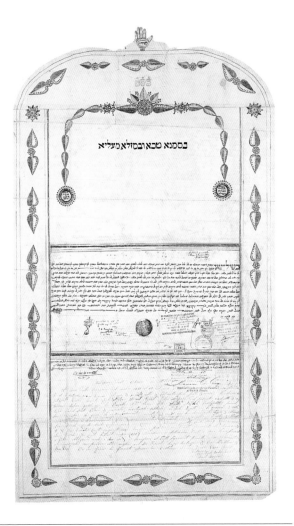

*In the middle section of this ketubbah, below the
text, are signatures of witnesses to the marriage
and the stamp of the rabbinate of Istanbul, where
the wedding took place. The lower compartment
features an Italian translation of the contract, and
signatures of the Grand Rabbi of Paris and of
Belgian and American officials. At the very top of
the ketubbah is a ḥamsa, an open hand inscribed
"Almighty" in Hebrew. An amuletic device, the
ḥamsa has been used since antiquity to guard the
individual against the Evil Eye. Popularized in
Islamic countries as the hand of Fatima (Mu-
hammad's daughter), the device was adopted by
Jews, who usually inscribed it with one of the many
names of God as a sign of power against evil.*

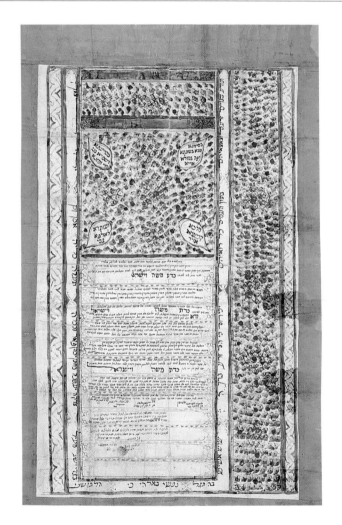

Plate 25

*Bride: Hannah, daughter of Elihu Kashi*
*Groom: Baba known as Matityah, son of*
*Isaac Muruti*
*Damavand, Persia, 1870*
*Ink, gouache, and gold paint on paper*
*31 1/2 x 20 in.; 80 x 50.8 cm*
*Gift of Amanollah Rokhsar, 1982-240*

*In 1871, shortly after this ketubbah was*
*issued, a famine swept through Persia,*
*severely affecting the Jews of Damavand,*
*a city situated at the foot of Mount*
*Damavand, east of Teheran. This ketub-*
*bah is therefore of great significance, since*
*very few Jews were found in that town*
*after the famine.*

Plate 26

*Bride: Zaleika(?), daughter of Ezekiel*
*Groom: Gabriel, son of Mordecai*
*Isfahan, Persia, 1879*
*Ink and gouache on paper*
*25½ x 17¾ in.; 64.8 x 45.1 cm*
*Gift of Dr. Harry G. Friedman, F 4224*

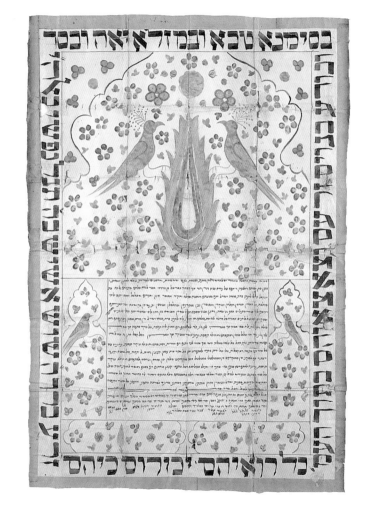

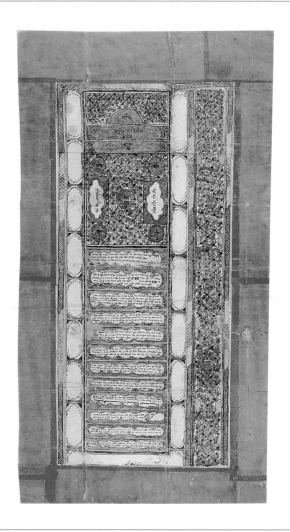

Plate 27

*Bride: Tawas(?), daughter of Amram*
*Groom: Jacob, son of Abraham*
*Teheran, Persia, 1885*
*Ink and paint on paper*
*40 1/2 x 22 3/4 in.; 102.9 x 57.8 cm*
*Gift of Dr. Harry G. Friedman, F 5820*

*The composition of this ketubbah consists*
*of a decorated panel at top and a series of*
*gilt frames below, each inscribed with a*
*text. This format was influenced by*
*Persian book decoration and is also found*
*on many Muslim marriage contracts.*

Plate 28

*Bride: Hannah, daughter of Sakhna*

*Groom: Jacob, son of Judah known as Lev*

*Amsterdam, 1886*

*Printer: Levissan Brothers*

*Print on paper; watercolor added later*

*12 x 7¼ in.; 30.5 x 18.4 cm*

*Purchased with funds given by the*
*    Judaica Acquisitions Fund, 1987-148*

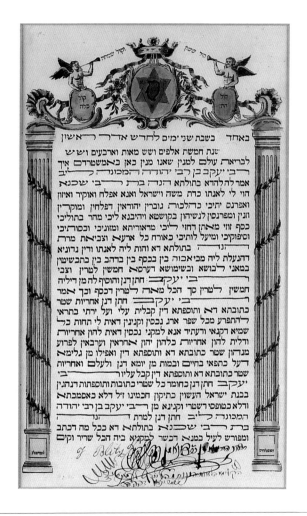

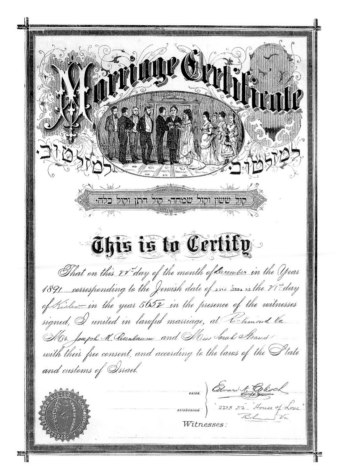

Plate 29

*Marriage Certificate*
*Bride: Sarah Straus*
*Groom: Joseph M. Rosenbaum*
*Richmond, Virginia, 1891*
*Printer: Bloch Printing Co.*
*Ink and print on paper*
*19 x 15 in.; 48.3 x 38.1 cm*
*Gift of Mrs. R. B. Rosenbaum, JM 1-49*

*This marriage certificate is written in English but includes traditional Hebrew verses that refer to marital happiness. A depiction of a ceremony is featured above the text. Rabbi Edward Nathan Calisch (1865–1946), a prominent religious and civic figure in Richmond, Virginia, active in the American Reform movement, officiated. He was the rabbi of Congregation Beth Ahabah in Richmond from 1891, the year he issued this marriage certificate, until his death in 1946. The congregation was founded by German Jews in 1841 and housed the first public school in the city.*

Plate 30

*Bride: Leah, daughter of Isaac*
*Groom: Bezalel, son of Moses*
*Buffalo, New York, 1892*
*10³⁄₄ x 8¹⁄₄ in.; 27.3 x 20.9 cm*
*Ink, print, and gold embossing on paper*
*Gift of Dr. Harry G. Friedman, F 5846*

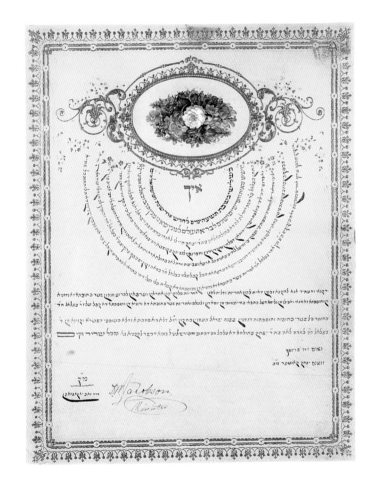

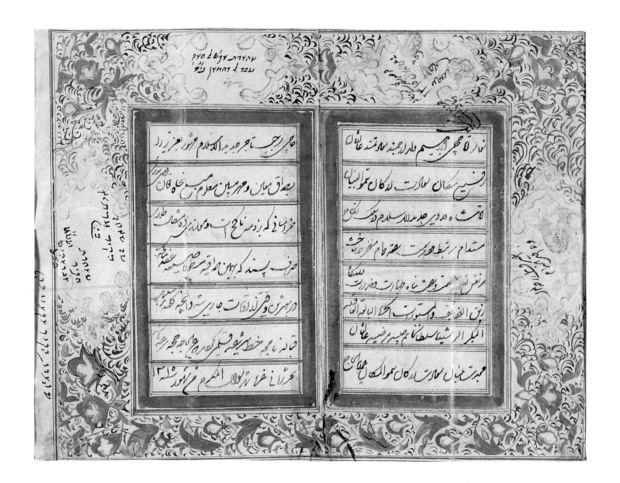

Plate 31

*Marriage Contract for "New Muslims"*

*Bride: Sultana Khanom, daughter of Hajji Rejeb Tajir* Jadid-al Islam *(known as Aziz or Azirad)*

*Groom: Shah Virdi* Jadid al-Islam, *son of Muhi Abraham*

*Khorasan Province (probably Meshed), Persia, 1898*

*Ink, watercolor, and gold paint on paper*

*8 x 10¾ in.; 20.3 x 27.3 cm*

*Gift of Dr. Harry G. Friedman, F 5724*

---

*The monetary unit mentioned in this contract was used in Khorasan Province, making the probable origin of the ketubbah Meshed, the principal city of that region. Although the Jews of Meshed were forced to convert to Islam in 1839, they continued to observe Judaism in secret. On the occasion of a wedding, two marriage contracts would be prepared, an Islamic document, such as this one, for public use, and a Jewish one for the home. In this contract, both bride and groom are referred to as* Jadid al-Islam, *or "New Muslim," the term used to designate forced converts. Although the text of the contract was written in Persian, the signatures are in Hebrew.*

Plate 32

*Bride: Esther, daughter of Solomon*
*Groom: Aaron, son of Baba*
*Damavand, Persia, 1898*
*Ink, gouache, and gold paint on paper*
*7 1/4 x 5 3/8 in.; 18.4 x 13.6 cm*
*Gift of Amanollah Rokhsar, 1982-243*

*This marriage contract is an early*
*example of Jewish use of the booklet form,*
*probably inspired by Muslim use of this*
*type of marriage contract beginning in*
*the second half of the nineteenth century.*
*These ketubbot were popular among the*
*Jews of Teheran at the beginning of the*
*twentieth century.*

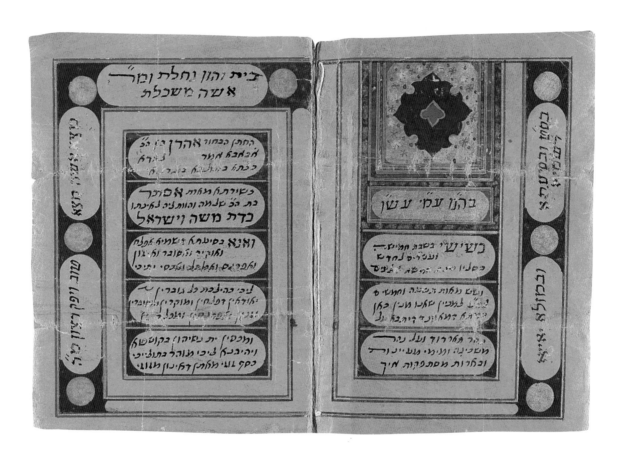

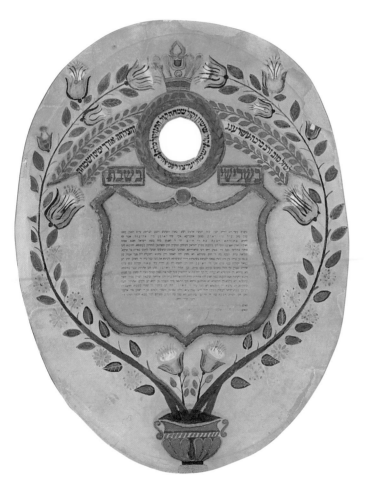

Plate 33

*Bride: Rebecca, daughter of Ḥayyim*
*Groom: Reuben, son of Eliezer*
*New York, United States, 1899*
*Ink, print, and watercolor on paper*
*25 ½ x 20; 64.8 x 50.8 cm*
*Gift of Dr. Harry G. Friedman, F 5668*

*This ketubbah is decorated with an urn*
*of flowers, a motif found in American*
*folk art. Two separate branches issuing*
*from the vessel may symbolize the union*
*of the newlyweds.*

Plate 34

*Bride: Minnie Kiwowitch (Minta, daughter of Ephraim Joseph)*
*Groom: Joe Wishnick (Joseph, son of Elijah)*
*St. Paul, Minnesota, United States, 1908*
*Probably printed in Vienna*
*Print and ink on paper*
*25¾ x 17¾ in.; 65.4 x 45.1 cm*
*Gift of Martin Weber, 1993-123*

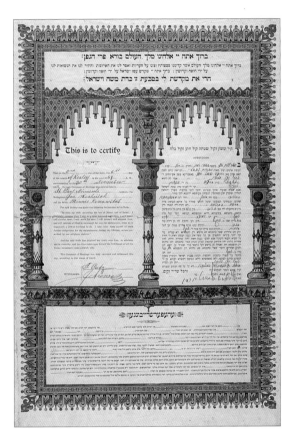

*The decoration on this marriage contract— a double-stalactite arch surrounded by geometric motifs—also appears on a fragmentary ketubbah from Rhodes dated 1908 in The Jewish Museum's collection (1984-76). While the Rhodes example bears the handwritten text of the marriage contract at right and the terms of engagement at left, this ketubbah includes the traditional Aramaic text printed on the right, and English and Yiddish versions of the same text printed on the left and bottom. The printer apparently made the decorative frame and left the text areas blank to be inscribed or over-printed later, according to the needs of the owner.*

Plate 35

*New York, United States, 1915*
*Artist: Leon Israel*
*Printer: Hebrew Publishing Co.*
*Printed on paper*
*16⅞ x 11⅞ in.; 42.9 x 30.2 cm*
*Gift of Daniel M. Friedenberg, 1993-172*

*This blank marriage contract consists of a certificate in English on the front side and the original Aramaic text on the back. The English text is decorated with the engraving of a bride and groom and a rabbi standing under the wedding canopy, surrounded by the wedding party. The artist, Leon Israel (known as LOLA), was a political cartoonist for Yiddish newspapers.*

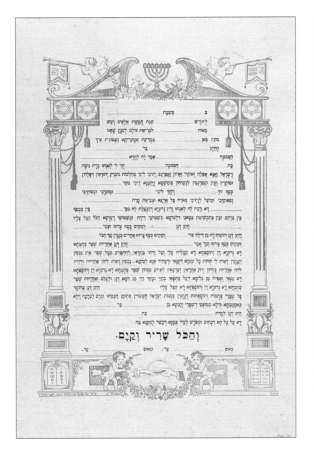

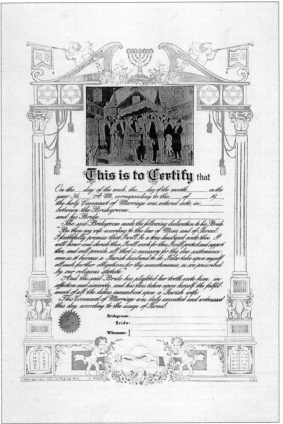

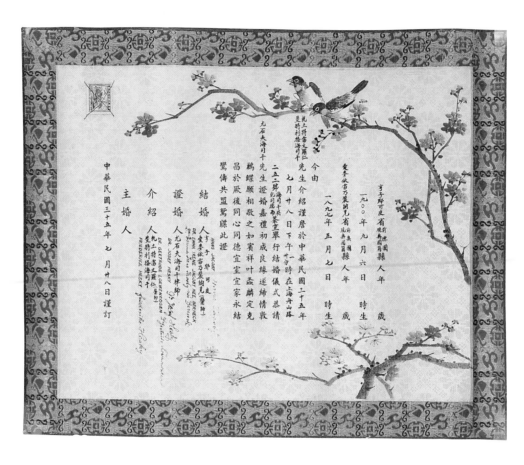

Plate 36

*Marriage Certificate*
*Bride: Dr. Emma Irene Jacoby née Berneck*
*Groom: Hans Jacoby*
*Shanghai, China, 1946*
*Manuscript and paint on silk pasted on paper;*
*    cardboard case*
*12 7/8 x 16 3/8 in.; 32.7 x 41.6 cm*
*Gift of Stephen Maurice Jacoby, 1993-170 a,b*

*Decorated with a cherry tree in blossom and two*
*birds, this certificate includes the names of the two*
*officers conducting the ceremony as well as the*
*name of the witness and his congratulations to the*
*bride and groom. Although it is not a Jewish*
*marriage contract, this Chinese secular document*
*is an interesting testimony to Jewish history.*
*During World War II the couple fled from*
*Europe to Shanghai, where they married. The cer-*
*emony took place in a tea room on Chusan Road*
*in Shanghai.*

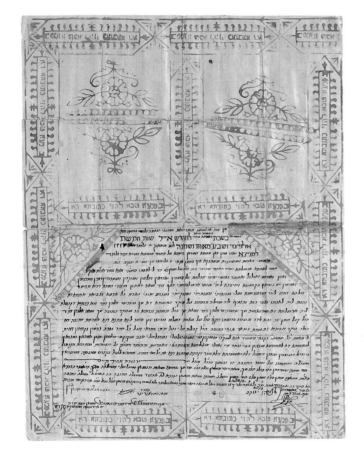

Plate 37

*Bride: Sarah, daughter of Solomon*

*Groom: Elijah, son of Jacob*

*Hamadan, Iran, 1948*

*Ink and block-print on paper*

*16⅝ x 13⅛ in.; 42.2 x 33.3 cm*

*Purchased with funds given by the*
*Judaica Acquisitions Fund, 1987-146*

Plate 38

*United States, 1961*

*Artist: Ben Shahn (American,*
*b. Lithuania, 1898–1969)*

*Ink, watercolor, gold paint, and pencil*
*on paper*

*26 ½ x 20 ½ in.; 67.3 x 52.1 cm*

*Gift of the Albert A. List Family,*
*JM 99-72*

*© Estate of Ben Shahn/Licensed by VAGA,*
*New York, New York*

---

*A Social Realist painter during the 1930s*
*and 1940s, Ben Shahn began to incorpo-*
*rate allegory and religious and mytholog-*
*ical symbols into his work after World*
*War II. The aesthetic effect of Hebrew*
*and English letters became an essential*
*element of Shahn's art, as in this ketub-*
*bah. Updating traditional scribal prac-*
*tices, the artist added a stylized Star of*
*David to certain letters. This contract was*
*never used.*

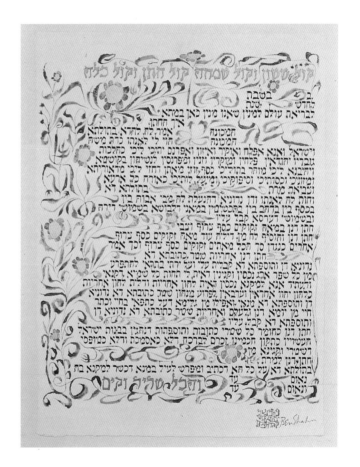

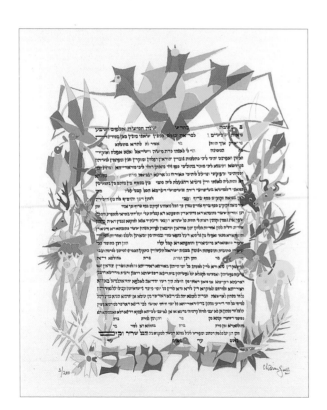

Plate 39

*New York, United States, ca. 1970*

*Artist: Chaim Gross (American, b. Galicia, 1904–1991)*

*Silkscreen on paper*

*24¼ x 20¾ in.; 61.6 x 52.7 cm*

*Gift of Fred and Rita Richman, JM 6-77*

*© Chaim Gross Studio Museum*

---

*Born in Galicia, Chaim Gross immigrated to New York in 1921. A sculptor and a draftsman, he attended the Educational Alliance Art School on the Lower East Side and, from 1927 until 1989, taught sculpture there. Gross began incorporating Jewish iconography into his work in the late 1940s, and he worked on commissions for synagogues in the 1960s. The decoration of this marriage contract includes stylized animal and floral motifs in vibrant colors. Unlike traditional ketubbot, Gross's text and decoration overlap in various places. The artist inscribed the city, New York, and part of a date in the text; however, the ketubbah was never used.*

Plate 40

New York, United States, 1989

Artist: Gregg A. Handorff (American, b. 1959)

Acrylic and flashe on canvas; potato-block letters

35 x 30 in.; 88.9 x 76.2 cm

Purchased with funds given by the Judaica Acquisitions Fund, 1990-146

© Gregg A. Handorff

In response to his rabbi's urging, Handorff designed his own ketubbah. Rather than adding a decorative border to the text, he made the text itself the focus of his art. The result is this unconventional, playful rendition of the text in festive colors. From the ketubbah used at his wedding, Handorff created a number of copies for his friends, of which this example was one.

# SELECTED BIBLIOGRAPHY

Davidovitch, D. *The Ketubba: Jewish Marriage Contracts through the Ages.* Tel Aviv: E. Lewin-Epstein Ltd., 1979.

Gutmann, J. *The Jewish Life Cycle.* Leiden: E. J. Brill, 1987.

Kleeblatt, N. L., and V. B. Mann. *Treasures of The Jewish Museum.* New York: Universe Books and The Jewish Museum, 1986.

Kleeblatt, N. L., and G. C. Wertkin. *The Jewish Heritage in American Folk Art.* Exhibition catalogue. New York: Universe Books and The Jewish Museum, 1984.

Makover, S. J. *The Jewish Patrons of Venice.* Exhibition brochure. New York, The Jewish Museum, 1992.

Mann, V. B. *A Tale of Two Cities: Jewish Life in Frankfurt and Istanbul 1750–1870.* Exhibition catalogue. New York: The Jewish Museum, 1982.

Mann, V. B., and R. I. Cohen. *From Court Jews to the Rothschilds: Art, Patronage and Power 1600–1800.* Exhibition catalogue. New York: Prestel and The Jewish Museum, 1996.

Mann, V. B., ed. *Gardens and Ghettos: The Art of Jewish Life in Italy.* Exhibition catalogue. New York: University of California Press and The Jewish Museum, 1989.

Mann, V. B., T. F. Glick, and J. D. Dodds, eds. *Convivencia: Jews, Muslims and Christians in Medieval Spain.* Exhibition catalogue. New York: George Braziller and The Jewish Museum, 1992.

Sabar, S. "The Beginnings of Ketubbah decoration in Italy: Venice in the Late Sixteenth to the Early Seventeenth Centuries." *Jewish Art* 12–13 (1987): 96–110.

———. "A Decorated Marriage Contract of the Crypto-Jews of Meshed from 1877." *Kresge Art Museum Bulletin* 5 (1990): 22–31.

———. *Ketubbah: Jewish Marriage Contracts of the Hebrew Union College Skirball Museum and Klau Library.* Philadelphia and New York: The Jewish Publication Society, 1990.

———. *Mazal Tov: Illuminated Jewish Marriage Contracts from the Israel Museum Collection.* Jerusalem: Israel Museum, 1993.